ADVANCE PRAISE FOR *NO MIST*

"Keiko Agena has written a little gem. *No Mistakes* is an artistic workbook that encourages, inspires, and comforts the creative artist in all of us. Filled with thoughtful exercises, this book helps artists evaluate and break through their creative blocks, shape their artistic perspective, and recognize the unique gifts they have to share with the world."

—Jenna Fischer, actress, *The Office*

"*No Mistakes* is the perfect friend to have with you on your creative journey. Kind, encouraging, thoughtful, and imaginative, this companion will help you find inspiration in places you'd never think to look. I sincerely hope that Keiko gives me a free copy once this goes to print. And if not, then I will definitely buy one, quietly resent her, and then use that resentment as a springboard to make something cool."

—Randall Park, actor, *Fresh Off the Boat* and *Veep*

"Keiko encourages a way of thinking that is so straightforward, accessible, and well articulated that I already feel a weight lifted. Our creativity is there, just waiting for us, if we can manage to lighten up and let the positive thoughts take over."

—Lauren Lapkus, actress and comedian

"If I'd had access to this book years ago it would have saved me so much money in therapy! If you are plagued by self-doubt, if your fears are keeping you from making creative progress, check this out. The bottom line is this: you're supposed to make mistakes! Embrace them! Make friends with them! Let them lead you down different pathways—you might discover something better than your original idea!"

—Wendi McLendon-Covey, actress, *The Goldbergs* and *Bridesmaids*

"I've always known Keiko to be an artist who pushes herself to expand what's possible. *No Mistakes* is the perfect glimpse into the nuts and bolts of how she does it—reading it is like taking your creative imagination for a day at the spa."

—Sean Gunn, actor, *Guardians of the Galaxy* and *Gilmore Girls*

"*No Mistakes* is your book BFF egging you on to take risks, make wild creative experiments, and fail spectacularly—and to keep going anyway while enjoying the messy, frustrating, imperfect, and exhilarating journey of artistic self-discovery and self-love. This journal is an inspiring gift for your inner creative child (remember her?) and a powerful talisman to ward off all the inner critics who tell you that you are not good enough or talented enough to live your most magical and creative life."

—Yumi Sakugawa, author of *The Little Book of Life Hacks: How to Make Your Life Happier, Healthier, and More Beautiful*

"There are many days when I feel like a janky piece of kid art. Keiko's book helps me underline the <u>art</u> and appreciate the janky. I'm excited to gift this to myself and to all the creatives in my life!" —Kulap Vilaysack, actress, showrunner on *Bajillion Dollar Propertie$*, and cohost of the *Who Charted?* podcast

"I smiled my way through this entire book. It was the gentle reminder I needed that making art is actually supposed to be fun." —Sarah Watson, showrunner on *The Bold Type* and writer on *Parenthood*

"I'm so grateful that Keiko wrote this book just for me, the only person in the arts who frequently gets in the way of her own creative process with perfectionism and/or negative thinking. This book is a fun and challenging way to recalibrate my brain when necessary. It's going to take a really long time to get all the exercises right, though." —Rhea Seehorn, star of *Better Call Saul*

"As a longtime mistake-maker, I'm so thankful for this sweetly optimistic book on redeeming our goofs for good! Keiko is the cool big sister we all wish we had, giving us the support we need to keep creating terrible, wonderful things." —Kevin Porter, host of the *Gilmore Guys* podcast

"*No Mistakes* is now going to be my go-to birthday gift. Perfect for my eighty-year-old dad all the way down to my crayon-wielding little cousins, everyone can benefit from Keiko Agena's ingenious way of instilling confidence in the heart of any aspiring artist." —Amber Benson, author and actress, *Buffy the Vampire Slayer*

"This book is about so much more than being creative. It's about how to embrace our imperfect selves, and how to live our lives with joyful exuberance. Everybody needs this book." —Misa Sugiura, APALA Award–winning author of *It's Not Like It's A Secret*

"Keiko Agena's *No Mistakes* is like a hug for my artist's soul. Every page is rendered with such empathy, wit, and humor—and every brain-opening exercise helped me rediscover my passion for the pure act of being creative." —Sarah Kuhn, author of *Heroine Complex*

"It's like the kind, brave part of improv became a person and wrote a book. This is the voice we all need in our heads as we make stuff." —Will Hines, veteran improviser at UCB and author of *How to Be the Greatest Improviser on Earth*

NO
MISTAKES

NO MISTAKES

A ~~PERFECT~~ WORKBOOK
FOR IMPERFECT ARTISTS

KEIKO AGENA

A TarcherPerigee Book

tarcherperigee

An imprint of Penguin Random House LLC
375 Hudson Street
New York, New York 10014

TarcherPerigee with tp colophon is a registered trademark of
Penguin Random House LLC.

Most TarcherPerigee books are available at special quantity discounts for
bulk purchase for sales promotions, premiums, fund-raising, and educational
needs. Special books or book excerpts also can be created to fit specific needs.
For details, write: SpecialMarkets@penguinrandomhouse.com.

ISBN 9780143131786 (paperback)

Printed in the United States of America
10 9 8 7 6 5 4 3 2 1

Book design by Daniel Lagin

FOR SHIN

In another universe this book is called Marry Shin. *That's equally good advice for creating a healthy, artistic life.*

But I don't know how many people would buy that book (since it's only one page long), and to be honest, I don't need the competition. So... you get this book instead. Enjoy!

CONTENTS

What if there were *no mistakes*? OK, not possible. But what if we could view our mistakes in a new light?

I'm Keiko Agena. Most people know me—if they know me—as Lane Kim, that adorable, dependable, musically gifted best friend to Rory on the TV show *Gilmore Girls*. What I'm less well-known for (unless you're a regular at the Clubhouse on Vermont) is performing in improv shows.

You see, in improv, there are no mistakes. When someone makes a "mistake" in a scene, it's up to the other improvisers to justify it. They create a world in which that mistake makes perfect sense. They double down on it. They embrace it instead of criticizing it. It's wonderful! There is nothing better than watching a group of people support one another unconditionally.

What does that have to do with this book?

For one, justifying mistakes is *how I draw*! I never have a preconceived idea of what a piece of art is going to look like. I begin with a line—a group of lines, with one going directly off the line before it, just like the lines in an improv scene. If I make a "mistake," something that I don't like, I add *more* to balance it out. Or, better yet, I repeat it as a pattern. My mistake has suddenly become a *design choice*! More times than not, it ends up being my favorite part of the piece.

Good for you. But how does that help me?

I appreciate your directness.

The goal of this workbook is to further develop your innate artistic ability by using the *No Mistakes* philosophy. Your ragged edges are what make you great. Stop smoothing them out. Your odd point of view, your imperfections . . . these are your treasures. The exercises in this book are designed to help you do three things: Discover your voice. Accept your voice. Express your voice.

Well. That might possibly be interesting. Guess I'll flip this—

page?

Awesome! See that? I totes guessed what you were thinking! Our collaboration is already on firm footing. I believe that art is all about collaboration and support.

And if, for some reason, you feel a little lacking in the collaboration-and-support area, know this:

I have your back.

Let's do this!

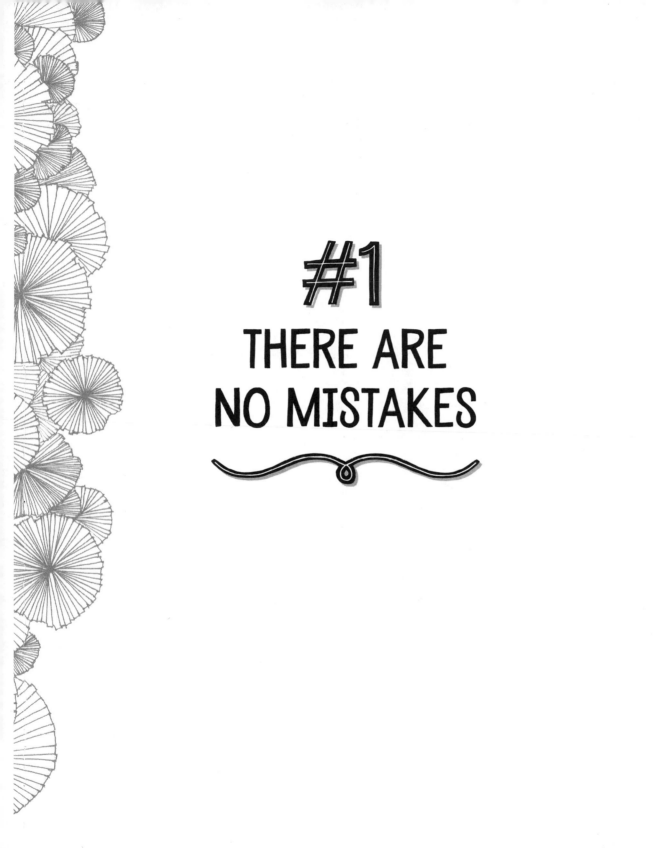

#1
THERE ARE
NO MISTAKES

Take a moment to rediscover what kind of artist you are.

As we go through life, we pick up and reject all sorts of things. We continually mold and remold ourselves into an ever-changing ideal. It's an ongoing process.

This is me. This isn't me. This is me, but it shouldn't be me. I do this thing, and because I do this thing, I am good.

Somewhere along the line we imprint in our minds an image of the *right* way and the *best* way to be. And while it's necessary to have goals, they can, at times, feel restrictive. Our desire for greatness should be a light that draws us forward, not a strict regimen that keeps us in a maze.

As an artist, your voice is vital. Your voice is what makes you unique. Your voice is your point of view. Too often we brutally shed the aspects of ourselves that we deem unworthy.

The quirks of our lives are our treasure. Today and every day, the challenge is to look at our mistakes in a different light.

A mistake is an opportunity.

A mistake is an unplanned moment.

A mistake is a feeling bubbling up.

Our job is to listen.

Ever see a really janky piece of kid art?

Why do we put it on the fridge? Because we know that kids need and deserve encouragement. Because we are used to looking at children and seeing potential.

Don't let that stop. Look at yourself with kindness. Know that you need and deserve encouragement. Get used to seeing your own potential.

Draw a really janky piece of kid art.

"Many people today believe that cynicism requires courage. Actually, cynicism is the height of cowardice. It is innocence and open-heartedness that requires the true courage—however often we are hurt as a result of it."

—ERICA JONG

FIRSTS

When a child learns to walk, we all want to be there to witness it. We want to record it. We want to celebrate it!

Do we know it's going to happen? Yes. Even though it seems difficult, we are sure that with time the child will walk. That knowledge doesn't lessen our excitement when it finally happens.

What milestones in your life have you glossed over because they were expected?

How would you celebrate them now?

Pssst . . . a tiny dot of ink can ruin a sweater. Does it have to? We all participate in the "parade of perfection," piecing together our homes and our clothes and our hair in an elaborate display of well-being.

But the *display* of well-being and *actual* well-being are two different things.

HELLO?

What are your mistakes trying to tell you?

Write out a mistake that keeps "happening" to you.

Imagine this mistake was the fault of a small child. It's clunky and ineffective, but it's a way for this child to get your attention and convey a message.

What do you think that message would be?

If this is a negative message, how would a kindhearted adult respond to this child?

Write down that response.

Take a minute. Hear this kindness.

DRAW WHAT IS BELOW THE SURFACE.

TRASH? TREASURE?

Find an old piece of art you've made that you don't love. Reread, relisten to, or rewatch it.

What is special about it that you want to keep? Is there a way to rework it? What was the impetus for it? Is that feeling still with you?

BRAINSTORM SPACE

DRAW YOUR MISTAKE

Quick. Pick out something in your room. Great! Start to draw it. As soon as you feel as though you have made a "mistake," shift your gaze away from the object. Continue to draw your item on the page.

Imagine this item exists on another planet or even in another universe. Let it morph into something unique to you. Say yes to the possibility that this could exist somewhere out there.

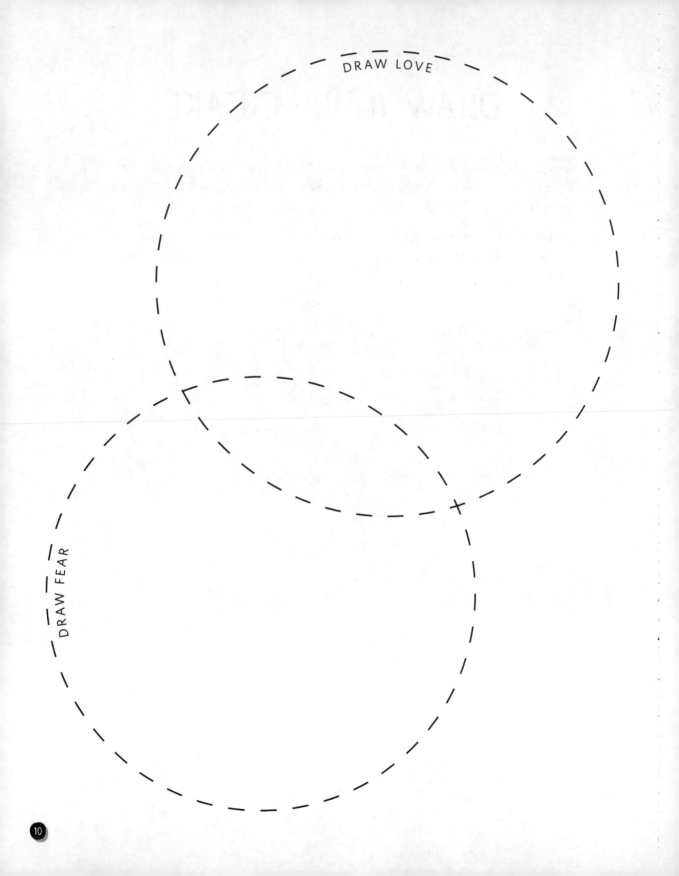

DRAW LOVE

DRAW FEAR

10

TASKS: PICK A FEW

1) CHANGEABLE VISION BOARD

Because dreams change. Get a corkboard. Stick up your inspirations. Create different sections for your different interests and goals. Allow beauty and ambition to have a safe home there.

2) BE THE IDIOT

"If it wasn't so naive, I would _____."

Do you ever look at someone having a joyous moment and question their intelligence? Somewhere along the line we have equated cynicism with intelligence. What would you do if you didn't have to spend so much time and effort looking smart?

3) DAYDREAM POSITIVELY

Have you ever had a great daydream going and a "real-world" worry snuck in to really stink up the place? For the next seven minutes, daydream positively. *Let go of all worry.*

P.S. Be wary of stuff that seems positive but is really a long list of things that you have to do *before* you can get that "positive" thing.

P.P.S. This could also be called Daydream Gratitude.

4) BREAK

Take a break from all media for one day.

5) BRAIN DUMP

Handwrite two pages of whatever comes into your mind. Trash it. Repeat the process as many days in a row as you can.

#2
LET INSPIRATION LIE
LIGHTLY UPON YOU

*Not crush you with the weight of expectation.

We are lucky to be inspired! We are lucky to feel yearning in our hearts when great art moves us. We are lucky to feel the thrill of excitement when exposed to new ideas and techniques.

Our luck fades, however, when we allow our admiration for great art to incite competition within us. When we get envious in our focus, our admiration suddenly becomes a burden.

Ugh, I could never be that good.

They are so talented. If I worked for the next sixty years I could never be like that. What's the point?

It seems that when we love, we love so hard and so passionately that we can crush ourselves with the pressure of living up to our heroes.

We mustn't let this happen.

Instead, allow your adoration to lie lightly upon you. Allow your influences to be with you in the room as you work, not hovering over your shoulder, judging your every move.

What inspires you should populate your world like friends at a cocktail party.

The great artists you look up to, who inspire you to do this work, have had years to get to where they are. Go easy. You are on your own path at your own pace.

LOVE

Imagine you are approached by a seven-year-old child. Describe to them what you love about what you and your mentors do.

"For the first couple years that you're making stuff, what you're making isn't so good, OK? It's not that great. It's trying to be good, it has ambition to be good, but it's not quite that good. . . . A lot of people never get past that phase, and a lot of people, at that point, they quit. . . . It takes a while. It's gonna take *you* a while. It's normal to take a while. And you just have to fight your way through that."

—IRA GLASS

bREatHe

HEAVEN OR HELL?

Decide on a positive track or a negative one.

Either fill up all the clouds with dreams that you want to come true and keep them in a place of honor, or fill them up with negative thoughts and destroy them afterward. Whatever works for you.

List the qualities you most admire in people.

Draw a portrait of your hero.

Write out a compliment you would love to hear someday.

What is an accolade you would like to receive?

Where is a special place that you have yet to travel?

What is an item you would like to have that would help your creativity?

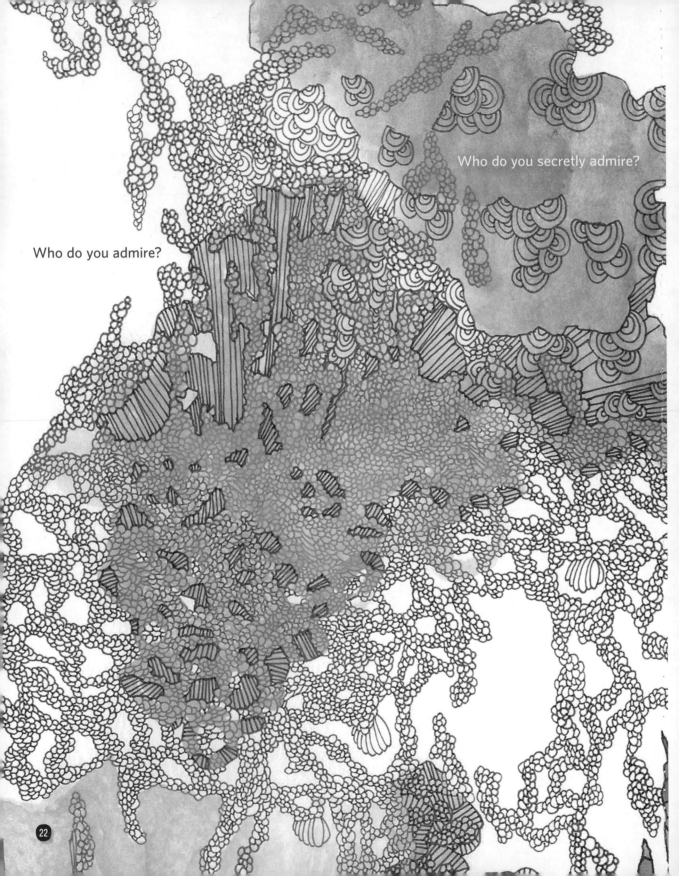

Who do you admire?

Who do you secretly admire?

22

We all have creative idols. Even if we try to copy them exactly, there will be some very noticeable differences. These differences (or "mistakes") are actually what makes our art unique. No other person will attempt greatness in the exact same way that we do. No other person will "fail" in exactly the same way that we do. This difference is our gift. Thank goodness for it!

1) YOUR IDOL'S IDOL

Pick an artist you admire.

(name here)

Find out what artists influenced them, especially in their childhood.

(list names)

Try to see how they "failed" at perfectly mimicking their idol. At some point they had to accept and trust their own voice and give it value.

2) APOLOGIZE TO YOURSELF

Pick something big or something small and apologize to yourself.

(write out your transgression)

Here's the zinger: FORGIVE yourself. If you don't think you can, I'll give you permission. This is me giving you permission.

What are you observing
about your environment right now?
Use this page to doodle about it.

After you fill the page,
is there a way to find stillness
amid all the distraction?

Secret:
We are irritated all the time. There are
small distractions constantly. But we
can learn to control how much weight
we give them.

"ENOUGH! I GET IT. . . ."

Sure, teachers are great.

Beloved teachers will instill in you a set of rules meant to make the process of learning your craft easier. Over the years, these rules become embedded in you; they become your tool kit.

But there does come a point when you need to kill the "teacher's voice" in your head.

In order to continue to grow, you have to find your own way. You have to shed the obligation to do it "right" in favor of emboldening your own process.

DEAR JOHN LETTER

Break up with your mentor. I know, this seems crazy. Use this exercise only if it speaks to you.

You won't show them this letter. Use it as an exercise to give yourself permission to find your own path. List all the things that you are grateful for, and then say your good-bye.

I'll be honest.
When I get scared, when I'm
sure I'm about to fail at
something, terrible words
spring into my mind.

Words about failure, hate,
and disgust clamor
in my head. They repeat
themselves over and over
and over.

I've found that these bad
mantras are an attempt to
push down feelings and
control fear. I physically
tighten against emotion. In
my attempt to protect myself,
I tense up. But the tension is
worse than the feeling.

The feeling will dissipate,
if I let it.

What bad habits can you let go of?

First by acknowledging them, and then with this mantra: "Release, let go, surrender."

#3
FAILURE IS FODDER
FOR COURAGE

PERSONAL FAILURE

(Yeah, this book is called *No Mistakes*... but let's take a look at what the feeling of failure can do.)

I have failed... *a lot*. There were numerous auditions for acting roles I thought I did well at, but I didn't book the job. There were many auditions I meant to do well at, but I didn't do well *at all*. (I actually had a casting director say these words to me: "Hon, don't beat yourself up too much on the way home.") I have failed at remembering names, failed at producing events, failed at being funny on a talk show. I have failed at being funny onstage, failed at playing it cool, failed at being open to new ideas... and many, many, many more.

The only way to avoid failure is to avoid starting. But that's a temporary fix. The pressure builds up in the void of action. Feelings of failure following long periods of inaction are *the most* difficult to deal with. The pain of wasted time is a monster.

I don't like failing. I don't like admitting that I've failed. I don't think that failure, in itself, by itself, is so great.

I do think, however, that it's part of the bigger picture.

I do think that it's part of the process.

I do think that it's going to happen.

And by the way, there is never as much artistic freedom as after a *big* personal failure. When your ego surrenders and you go back to square one and all the blocks are taken away, *that* is where brilliance is born.

So, I suggest you fail now. Fail soon. Fail often. Learn what you can, and let it go.

When you have nothing to lose, *that* is when you can take the biggest risks. Rediscover your love for your art when you let go of your perceived success.

Write or draw something ready to be born within you.

"Fall seven times; stand up eight."

When you are in darkness, the impulse is to draw more darkness into you. The words *always* and *never* start showing up: I'm *never* going to be good. Why do I *always* suck? *Resist*. Draw in light, even a little. Start with a *maybe* if you need to. *Maybe* this will get better. *Maybe* I will learn from this. Then start to pull in the positivity. Make PROMISES to yourself. I *promise* there will be a time when it won't feel this hard. I *promise* there is something good that will come out of this. Practice using this downtime as an opportunity to exercise the skill of self-care. As an artist, you are going to need this skill. Find the words and healthy activities that work for you. Learning to get out of a funk is more valuable than never getting into one.

2 P.M. ON A SUNDAY

Write down the name of one of your heroes.

Now imagine it's 2 p.m. on a Sunday and you are a fly on the wall of this person's home or workplace. Your hero has just gotten some very bad news about a project. How do you think they would handle it? Good or bad, you are just an observer. Sit for a minute in observation of them. I bet they feel as deeply as you feel. Handling failure is part of their job. How would you handle it?

DOODLE SOMETHING "WRONG"

This is a trick. It's a doodle. There is no right or wrong.

List all the things you've failed at. If you can't finish this list, get out there.
You have a lot more failing to do!

_____ _____ _____

_____ _____ _____

_____ _____ _____

_____ _____ _____

_____ _____ _____

_____ _____ _____

_____ _____ _____

_____ _____ _____

_____ _____ _____

_____ _____ _____

_____ _____ _____

_____ _____ _____

_____ _____ _____

_____ _____ _____

_____ _____ _____

_____ _____ _____

_____ _____ _____

_____ _____ _____

_____ _____ _____

DIE

Please, don't actually die. But let your old ideas die. What freaking crappy, old, moldy, dumb idea have you been carrying around with you that you are ready to let go? Write it here. Feel free to use a big red pen to scratch it out.

DIE 2

Please, seriously, don't actually die. But let some of your old hopes die. Sometimes there are things that we yearn for that start to feel more like burdens than dreams. Is there something that you have outgrown that you want to let go of? Or is there a "wish" for you that someone else placed on your shoulders that you have been carrying around for years? Write it here. Scratch it out. If it is your true calling, you can pick it back up later.

DRAW WHAT CHANGE FEELS LIKE

FOR THREE WEEKS,
DO ONE THING THAT
SCARES YOU EVERY DAY

☐ Monday _____

☐ Tuesday _____

☐ Wednesday _____

☐ Thursday _____

☐ Friday _____

☐ Saturday _____

☐ Sunday _____

☐ Monday _____

☐ Tuesday _____

☐ Wednesday _____

☐ Thursday _____

☐ Friday _____

☐ Saturday _____

☐ Sunday _____

☐ Monday _____

☐ Tuesday _____

☐ Wednesday _____

☐ Thursday _____

☐ Friday _____

☐ Saturday _____

☐ Sunday _____

Leap and the net *might* appear. Leap anyway.

It's OK. Falling down is just as useful to us.

WRITE

about the bravest person you know.

DRAW

what that inspires in you.

BONUS SECRET:

No flagellation necessary. Sometimes we actively stress ourselves out because we convince ourselves that that's what working feels like. We think that if we're not producing art, at least we're stressing about it. Nope.

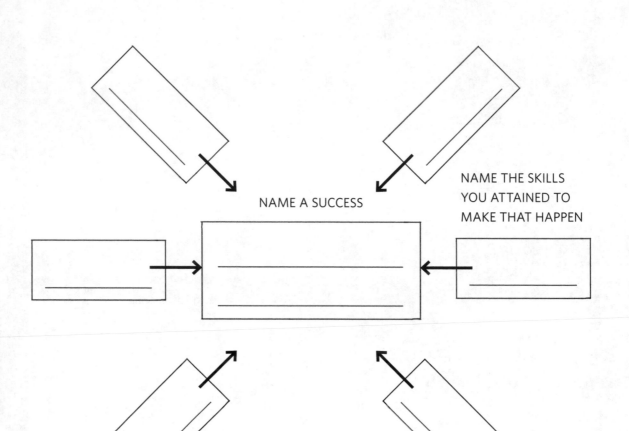

NAME A SUCCESS

NAME THE SKILLS
YOU ATTAINED TO
MAKE THAT HAPPEN

NOTE

There are *many* skills required to achieve our successes.

Remember, regardless of the result (success *or* failure), we get to *keep* these skills.

BROKENHEARTED

Rejection is part of the creative life. And it hurts. A lot. Why? Because our vulnerability is required to do good work. We have to put our *full* heart into it. We have to care. We have to invest.

When we are rejected, that loss can feel like a physical pain in the chest. Being able to transition out of this pain is difficult but necessary. Every new project deserves our full heart, nothing less.

Draw or describe the perfect funeral for a project you loved that ended.

Remember to take the time to honor your effort.

#4

GRATITUDE IS
THE CURE FOR AN
ANXIOUS MIND

CONFESSION

I am anxious *a lot*. In my many years of being an anxious person, I will say that my anxiety is either forward thinking—trying to find out *all* the booby traps and sinkholes and quicksand spots my day might have—or it is running over and over in my mind an event in my past when I did or said something wrong, trying futilely to imagine what other people thought of me at the time and what they might be thinking about me now.

I'll tell you one thing about being anxious: It's not about living in the present moment. It doesn't live on the breath. It isn't quiet. It isn't still. Anxiety is all about what I feel like I don't have now or what I am afraid I won't have in the future. Most times, for me, it is wrapped up in a future scarcity, a fear that there will come a time when I will need something and no one will be able or willing to help me.

GRATITUDE IS THE CURE FOR AN ANXIOUS MIND

Gratitude lives in stillness, in an open heart. It is a willingness to *see* the abundance in our lives. All the many things that we lump together and call "life" or our "normal" or our "everyday" or our "burden" gets broken down into all its intricate parts. When we allow ourselves to fill up with gratitude and appreciate the things that we *do* have, we are immediately more in this moment. Filled with an understanding and appreciation for the support that we *do* have, we are present.

Anxiety, seeing that there is no space for it in this environment . . . will become lighter . . . and slip away.

"Your unhappy person resents it when you try to cheer him up, because that
means he has to stop dwellin' on himself and start payin' attention
to the universe. Unhappiness is the ultimate form o' self-indulgence."

—TOM ROBBINS

TRAFFIC JAM

Many times it's the second, third, or fourth idea after the first "bad" one that is good. But it's like a traffic jam. You've gotta let out the bad ideas first so that the others have a chance.

LIST OF BAD IDEAS

SILENT OBJECTION

Are you *really* good at picking apart some new proposal and analyzing why it won't work out? Do you see all the ways a new idea can go wrong? Here's your challenge. Next time, *don't* speak up. At least not at first. If your superpower is noticing all the flaws in a proposal, become aware of the opposite. Hold your tongue until you think of a solution. Exercise your problem-*solving* muscle instead of your problem-*finding* one.

WHAT ARE YOU GRATEFUL FOR?

What people see...

Who I am...

Who I am becoming...

ANGER

. . . is different from hate. You can be angry about something and be motivated into action! Hate eats away at *you*, not at the focus of your hate.

GRUMBLE LIST

List all the things that annoy you.

Write out actual actions
that you can take.

Once you've done
those actions . . .

let it go.

LUCK!

Hey . . . there is a bit of that too.

Write or draw some lucky talismans.

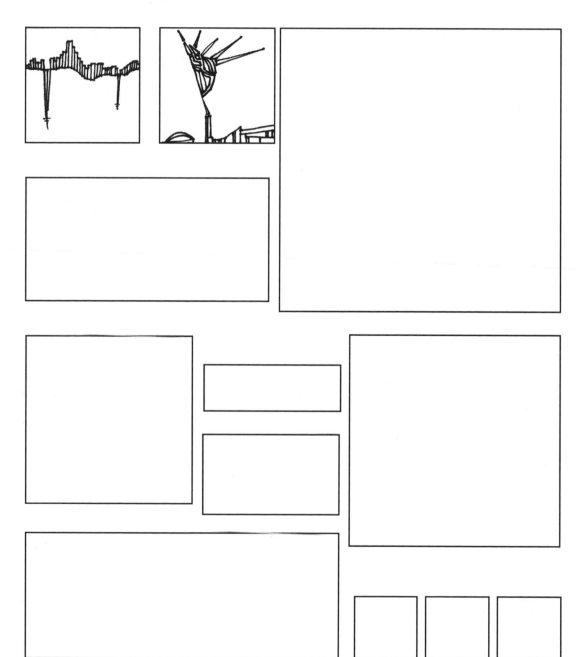

GROW THE SEED

You wouldn't put a seed on a slab of concrete and hate it for its weakness and failure to grow. Creativity, like a seed, needs nourishment to grow. What does your seed need? A dedicated (no bills, no computer, no food) art desk? Does it need allotted time? Or a trip to the craft store? Does it need to go see that weird, dark movie that no one else wants to go to?

Make a list or draw what your seed needs.

MOVE YOUR BODY

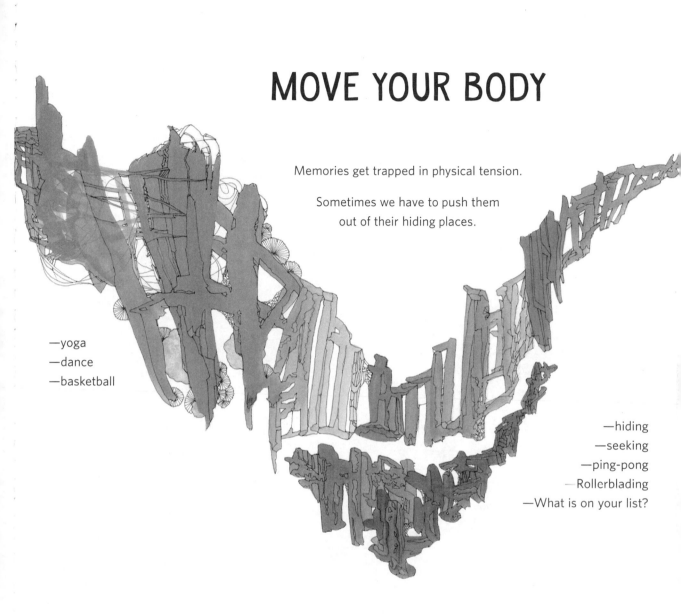

Memories get trapped in physical tension.

Sometimes we have to push them
out of their hiding places.

—yoga
—dance
—basketball

—hiding
—seeking
—ping-pong
—Rollerblading
—What is on your list?

Our memories are the building materials that make our art.

If it weren't too greedy to
ask of the universe,
I would ask for _____ .

If I were ever strong
enough to handle it, I
would ask to be _____ .

If I could somehow let go of my nerves long enough,
I would definitely _____ .

If it wasn't such a risk, I
would want to _____ .

If I could ever find enough
support, I would probably
try _____ .

It's way too scary, but if it
weren't, I might find _____ .
exciting.

If I didn't worry about
disappointing people, I
would probably quit _____ .

#5

QUIT TRYING TO MAKE YOURSELF BALANCED

Invest in what you love.
Double down on that.

Sometimes fixing our inadequacies feels impossible. It feels insurmountable. It feels as if they're the *only* things people notice about us. We obsess about minimizing our shameful faults. We expend so much effort correcting our weaknesses in an effort to feel more "normal."

Screw it.

No one notices those things as much as you do. What if you switched your focus? What if you spent as much time focusing on the things you are *good* at? What if you didn't discount those things because they're so "easy" that "anyone" could do them?

Because *they* can't. Because *you* are really good at it; you are talented in *this* area. What if you really valued this thing? What if you doubled down on it?

When you invest in what comes easily to you,
when you value the talents that you have,
you experience exponential growth!

Weeds are freaking strong. Trees that are native to an area flourish quickly. Manicured lawns, however, take *a lot* of effort.

What is wild and natural to you?
What is your strength?

What is your area that requires effort and control?

"You will recognize your own path when you come upon it because you will suddenly have all the energy and imagination you will ever need."

—SARA TEASDALE

SECRET LYRICS

What is a song you wish someone had written for you? What attributes would you want someone to obsess about? What adorable, weird strengths do you have that only someone who knew you really well would mention?

YOUR EXPERTISE

Design your book cover. Create the title and artwork. What are you an expert at? What niche do you know *a lot* about?

We hear this story a lot.

So-and-so was *so* driven, they accomplished (blank) and (blank) and (blank) because they were trying *so* hard to fill a hole inside them.

What hole are you trying to fill?

Challenge: Find a way to fill this hole in a *meaningful* way: with friendships, charity, spirituality, gratitude, generosity. . . . Trust that you are not sacrificing success when you do personal work to make yourself healthy. The path of the tortured artist is not the only path. And I would suggest that it is not the best one.

Our scars bulge because they are
overcompensating. For what hurt
are you overcompensating?

SOMETIMES YOU NEED A BREAK

Take a shower.
Take a nap.
Bike ride to the post office.
Pay bills.
Watch *Rick and Morty*.
Call your mom.

If you are moving along with a creative endeavor,
listen for when you need to unplug. Many times
you will be more productive afterward.

DRAW WHAT BALANCE FEELS LIKE

P.S. Not every piece of advice is meant for you.
We all have different strengths and weaknesses.
What is some terrible advice you have been given?

By naming it, you take away its power over you.

Ever notice a child who just needs a nap?
It's obvious to us, but they don't see it.
The longer they go without it, the grumpier
they get. They are determined to fight
against a simple thing that they need.

What are the simple things your inner artist
needs in order to not be grumpy?

#6
MAKE THE ART YOU
WANT TO HAVE

Think about the art you have on your walls or the books you have on your shelves. There is a reason you brought these items into your home. They inspired you. They challenged you. They excited you.

That passion for art is the kind of passion you want to inspire in others.

It's a high bar; I agree. But it is one worth striving toward. Respect your viewer as if they were you. They are as smart as you, as sarcastic as you, as loving as you, as adventurous as you. Maybe even more so.

When you create for yourself, you kill three birds with one stone.

First, you make things that are unique to your palate and thus unique to the marketplace.

Second, you make high-quality art because you never underestimate your audience.

Third, you stay on track. When faced with a difficult artistic choice, check your gut. Which choice would satisfy *you* the most as a viewer?

Over time this skill will become one of great importance. It's much easier to trust your gut when you have practice doing it.

SIDE NOTE

This book is the book I needed to read in order to be able to write this book.

KEEP THIS PAGE. POST IT WHERE YOU CAN SEE IT. CREATE WHATEVER YOU WANT.

*Be aware of how you change your approach if you know ahead of time it is something that you are going to put on *your* walls.

"Always be a first-rate version of yourself, instead of a second-rate version of somebody else."

–JUDY GARLAND

We all know the story of the tortoise and the hare. Slow and steady wins the race. Truth is, we are the tortoise *and* the hare. Make use of both times. When you feel hyper and super active, *do a lot*. Write a lot. Draw a lot. Create a lot. Capitalize on the creative gift. *And* allow yourself to plod along when necessary. Resist the "fault" of the hare, of distraction and overconfidence. Instead, allow yourself to switch gears and plod forward slowly when that is required. Fill this page with hybrid animals to keep this bunny-turtle company.

Secret:

The finish line keeps moving because *we* move it. Don't forget to pause for a minute in gratitude before you start the next race.

You have a *high bar* for art. You have good taste. When you make something, aim to satisfy *yourself*.

"The public" is just as smart as you are.

Don't let yourself off the hook.

What excuses have you been making for yourself lately?

You may think...

"But nobody else is like me."

"I'm too weird."

"If I make what I like, it's too specific."

"No one will get it."

Bollocks.

There are seven billion people on this planet.

Your art is *not* going to appeal to 100 percent of the people. Name one artist's who does. It is not possible. Don't worry about making art for everyone. We all want and like different things. Make something that *you* love and respect.

ACTION ITEM

SINCERELY TRY something NEW.

Earnest effort. No caveats.

This page left blank on purpose.

This is the BLANK space where all your caveats go to die.

Armor is wonderful for battle.

Armor is terrible for washing dishes, yoga, putting the kids to bed, or swimming.

Know when to set down your defenses.

You are not always fighting a war.

*Fill this page with bubbles.

One of the hardest things to do as an artist is to accurately talk about ourselves. If we exaggerate, we seem like blowhards. If we don't mention what we do, we can miss out on opportunities. Framing what we do—accurately—is important. It's not usually a comfortable feeling, but practice can make it seem more natural in public.

Describe or frame two of your accomplishments.

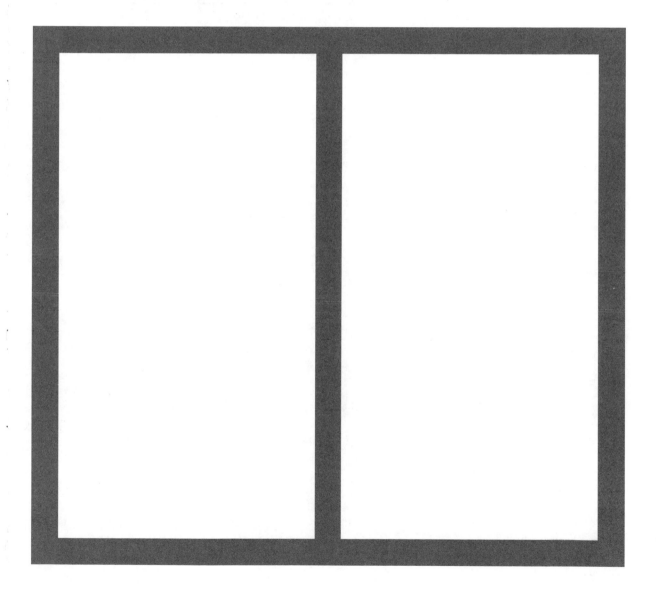

TIME LIMIT

This might sound scary, but consider it as an option.

If in five years I am not _____,

<div align="center">(name a big goal)</div>

I will stop pursuing this path. I will switch my focus to something else.

<div align="center">(your signature)</div>

This idea is not for everyone, but if it speaks to you, here are some advantages:

You KICK BUTT for five years, because you know there is an end.

You focus and give everything you have, because you know there is a good chance you'll be walking away.

If at the end of five years you have exhausted yourself in this endeavor, you can walk away with your head held high: *I gave it my all. I walked away. I will take what I've learned and pursue something else.*

LITTLE BIT OF POISON

We love alcohol and coffee.

Why?

For the kick they give us.

But in reality, they don't "give" us anything. The kick is all you. It is *your* body's resilience and fight that gives you that pleasurable feeling.

Treat any snide comment like a little bit of poison—just enough to get you fired up

and

kick some butt.

#7

CHERISH
YOUR VOICE

Your voice is unique.

Your voice is unexpected.

Your voice is shaped by your experiences, good and bad.

To cherish your voice is to accept it and to understand it. When you cherish your voice, you give it the space to express itself. You give it the space to communicate honestly. You give it the opportunity to heal.

When you cherish your voice, you stop chiding it and deriding it for not being someone else's voice. You let go of comparisons to your contemporaries. You surrender your grip on envy.

When you cherish your voice, you invest deeper in your uniqueness. You fill up with gratitude for what you have. You flood your heart with joy and appreciation.

When you cherish your voice, you live in the details. You pay attention to the shape of your art and all its elements. You listen harder. You are more playful. You live in the moment of discovery and exploration.

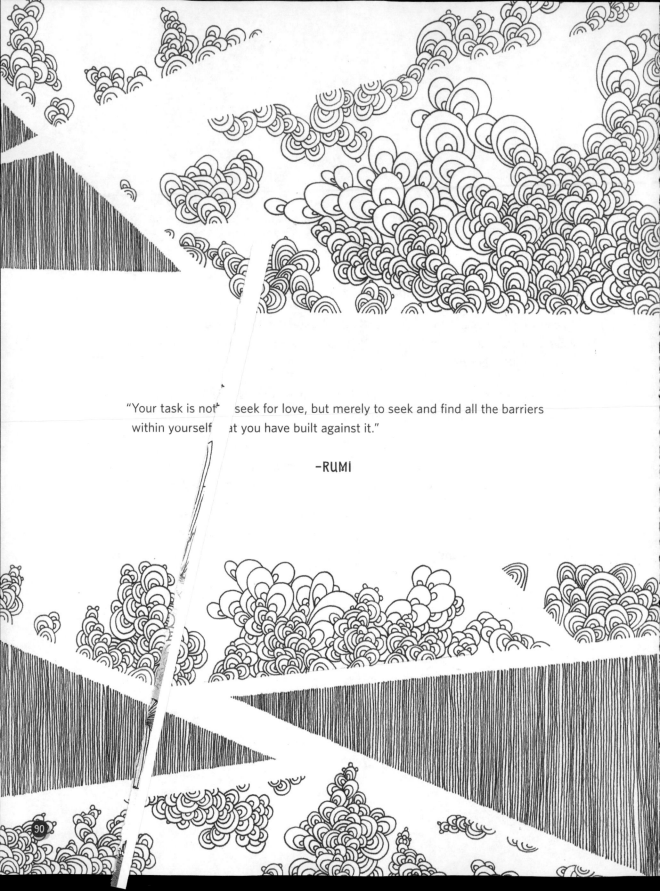

"Your task is not to seek for love, but merely to seek and find all the barriers within yourself that you have built against it."

—RUMI

ADVICE

"When you're tired, rest."

ADVICE

"When you're tired, keep pushing."

Both pieces of advice are right.

In time you'll know what *you* need, and when. Every circumstance is different. Your task is to trust your instincts, *not* to waste time beating yourself up.

What do you need right now?

(circle one)

REST PUSH

DRAW A BEAUTIFUL PICTURE OF AN UGLY DOG
OR AN UGLY PICTURE OF A BEAUTIFUL DOG.

HOLD YOUR HEART

Like, literally. (Well, not *literally* literally.)

Place your hands over your heart.

Close your eyes.

Breathe.

Ask this question: "What do I value?"

Write or draw the answer.

Then ask this question: "Have I been acting as if I value this?"
Write the percentage you have been acting as if you value this in the box.

☐ %

PROTECT YOUR CANDLE

What is your candle illuminating in you?

What are the forces that are attempting to extinguish it?

—Critical inner voice?
—Lack of time?
—Excessive outside "wind"?

(By "wind," I mean that person who is full of BS and can't stop putting you down. That guy.)

Celebrate the variables: the position of your hands as you hold this book. The pace of your breath. The tightness in your jaw. The images in your mind. Every person has a different experience, a different opinion, as they read this line of text. How fabulous! The words in your mind, the yearning in your heart? They are unique to you. They are your treasure.

Make a list of the thoughts you attempt to hide because they are too weird.

Awesome!

This book is your safe space. Within these pages, allow yourself the opportunity to explore what you really think about the world. As artists we are always revealing truth. We must allow the space to discover what we think and feel without censorship. What is your truth?

The reason we laugh at positive affirmations is because they sound foreign—but why should they? If I asked you to list five negative things about yourself, you could rattle them off with ease. These sound "normal"; they sound like "your voice." Why shouldn't the opposite be true—why shouldn't we be able to list positive things? We can. We just need to make a habit of it.

AFFIRMATION BUILDER

Negative things you say about yourself.

What is the opposite of that? These are your affirmations.

P.S. I know these sound weird. Like, really weird. That's OK. The more they sound as if they could *never* be how you see yourself, the more you need them. Use TIME. Time is a powerful ally. Say these things to yourself as often as you can. I promise, over time they will become part of how you see yourself.

TASKS: PICK A FEW

1) HONOR your work by putting a piece of it in a sacred place. Find a shelf or corner or mantel that means something to you. Put either an actual piece of your art or an important object that represents your art in that place.

2) WRITE a letter of gratitude to the one who created you, for your talent and intense interest in your field. Or, if you are an atheist (like me) *still* write a letter of gratitude! How crazy is it that in all the randomness of this universe you received the talent you have? Answer: super crazy.

3) GO BACK and find something you created long ago. What about it is *uniquely* you? See if you can find the common thread with what you do today.

4) WATCH some documentaries about creative people. All the subjects have quirks. Some of them are extreme. If there were a documentary about you, what would your quirks be?

5) PUSH HARDER into that awkward place. If there has ever been something about your art that you were criticized for but that you still liked, create a secret file. This is the "secret you" space. Focus on and indulge in this not-to-be-seen, secret art. There will be many gems there.

6) LOVE YOURSELF. OK, this task is a cheat. Of course, duh, we all want to love ourselves. Thanks, Captain Obvious. So I guess I will say this: The next time an opportunity comes up for you *not* to love yourself . . . stop. Do this task instead. Because. Because I say so.

LIVE!

It's the zombie apocalypse. Draw all the items you would take with you if you had to run.

THERE IS NO ONE LIKE YOU

You are unique. Acknowledging uniqueness is an ART and a PRACTICE. When we look for it in other people, we get practice.

List three people you know.

In what ways are they utterly, beautifully unique?

[]

[]

[]

Secret: Sometimes keeping a secret holds us back artistically.

What secret are you ready to share?

#8

FIND YOUR PEOPLE

Discover the ragtag community that gets *you*.

Making art is hard, y'all. No joke.

As creative people we are driven to produce work. We have ideas we think are funny or unique. We have ideas to inspire or bring a greater understanding of a certain topic. Whatever the case may be, it's something we feel passionately about, something we're obsessed with.

And because we're invested in it, when it's time to expose our work, it's vital that it's received.

That means dealing with people.

Which people?

Your people.

To FIND them and CONNECT with them you have to (eek!) share your work, your opinions, your interests, your (dare I say it) contact information. You have to share yourself. This is how you discover your customers, your contemporaries, and your mentors. In person or online, this sharing is the difference between stagnant, secretive work and work that is forced to grow.

And Be.

Be trustworthy.

Be the kind of artist you would want to work with.

Be a healthy member of a community that you continually help to strengthen.

FRIENDS LIST

Write down your list of friends. Next to each of their names, write what you think they mirror for you.

_____ _____

_____ _____

_____ _____

_____ _____

_____ _____

_____ _____

_____ _____

FAMILY LIST

This is a broad term. It's whoever _you_ consider family. Next to each of their names, write what you think they mirror for you.

_____ _____

_____ _____

_____ _____

_____ _____

_____ _____

_____ _____

_____ _____

"It's the friends you can call up at 4 a.m. that matter."

—MARLENE DIETRICH

MAKE A LIST OF ALL THE PARTS OF YOUR CREATIVE LIFE
THAT YOU WOULD LABEL "PROCESS."

An actor's list might be:

—*auditioning*
—*memorizing lines*
—*going to class*
—*analyzing what went right or wrong*
—*volunteering for other people's projects*
—*learning how to handle jealousy*
—*keeping in contact with creative people*
—*etc.*

IN THIS BOX WRITE WHAT YOU THINK A WORKING ARTIST DOES

An actor's answer might be: getting paid to act in something that I like

FIND A WAY TO MAKE THE PROCESS ENJOYABLE.
(IT'S 90 PERCENT PROCESS.)

GO OUT

What? What is this thing of which you speak? Yes. I know. Going out sucks. It's terrible. There are people out there who you *don't know*! What could be worse? (Well, a lot of things . . . but let's not get into that.) *Out* is where new people are. People who just might get you and get what you do. So say YES to the next invite that you get. GO somewhere new. Be OPEN to a different point of view. SHARE what you are passionate about.

Write out all the reasons why this is an impossible thing to do. Write out why I am crazy for asking you to do this impossible thing.

Now, go out anyway.

Make a list of things that are "impossible" to accomplish as an artist because you are too _____.

●

●

●

●

●

●

●

●

(Dream Bigger)

What GROUPS of people do you write off because you assume they would never "get" you?

Who do you "box in" by holding on to these assumptions?

What art do you like?

Why do you like it?

Who else likes this?

COMPLAINING

There is this belief that complaining is fun. Yes, there is camaraderie in it. Yes, misery loves company. But what are you losing when you complain? Ever feel drained after a good stint of complaining? It can suck your energy and drive.

FRIENDS' NIGHT

For an entire evening, challenge yourself not to complain at all, about anything.

Did you succeed?

How was it?

Did you complain about my attempt to stop you from complaining?

If it weren't so long ago . . .
I would probably reach
out to these people.
I really liked them. ⟶

⟵ If it weren't so outrageous,
I would probably try to
reach out to these people.
I really admire them.

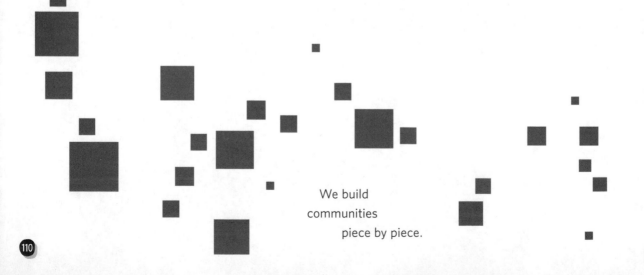

We build
communities
piece by piece.

Was there someone who told you you couldn't do something?

Or that you were "bad" at it?

What would you say to that person now?

To:

From:

Age:

I'll tell you a secret. . . . All artists need support.

From friends or family or an imaginary bird collective,
all artists need support. And that's OK. What we do is hard.

It's hard to be vulnerable and honest. The idea that we need to suffer
through the slings and arrows all by ourselves is heroic fantasy.
It's not necessarily an idea that will help you be productive.

Fill this page with hearts.

CLAIM IT

Your new best friend is out there.
(Don't worry, current best friend . . .
this is just an exercise.)

List five attributes you would want
them to have.

Which of these can you start
modeling yourself?

(Sometimes we have to show
people how we want to be treated.)

#9
PUT YOUR WORK
OUT THERE

OUT THERE is an actual place.
It is OUTSIDE your head,
OUTSIDE your home.

As artists we sense when work is too new for outside eyes. We instinctively protect it. We incubate it.

Be aware, however, that if we keep our art in our drawers—or worse, in our heads— we are just having a conversation with ourselves. While that might be gratifying, it's hard to learn that way, hard to grow that way.

The challenge, then, is transitioning out of that. How do we know when that protective time is over?

I say it's over now. SHOW IT TO THE WORLD!

Lucky for us, this is the age of social media. The "outside world" has never been so close. From the comfort of our homes we can start a blog, post an Instagram pic, write a joke for Twitter, film something for YouTube, or make a drawing for Facebook.

The timing is all up to us.

I say the sooner, the better.

We don't really "know what we know" until we are asked to share it. Take the opportunity to be generous with your time and knowledge.

Is there anyone who could use your support?

YOUR LESSON PLAN

(Doodle space)

"Our firmest convictions are apt to be the most suspect; they mark our limitations and our bounds."

–JOSÉ ORTEGA Y GASSET

I'M TAKING AWAY YOUR TOYS

(No cell phone, laptop, or books.)

DAYDREAM

Start with eight minutes.

This page is (mostly) blank.

It is your reminder.

There is always a little space in your day.

Let your mind wander.

THE PATH IS WIDE.
THE PATH IS MADE FOR YOU.

Decorate your path.

TASKS: PICK A FEW

1) BOLDLY DRAW where no one has drawn before. Mark the cover of this book. If you already have artwork, put it up in a place where you wouldn't normally put it.

2) GIFT a piece of art. Who says we have to stop sharing art because we no longer carry cartoon lunch boxes? (By the way, start carrying a cartoon lunch box.) Pick someone who would never expect it and gift them a hand-drawn note on an index card. They will love it.

3) HIDE IT on your body. Clip a favorite piece of art from a magazine, or better yet, draw something yourself. Fold it and keep it tucked away somewhere on your person—in a coat pocket or that unnecessary jeans pocket that is too small to hold anything else. It's your secret. Your art. Your bit of magic.

4) RECORD yourself creating your art. Use time lapse. *But I am just sitting at my computer for hours drinking coffee.* EXCELLENT. You definitely want to see a time lapse of that. It is extremely rewarding.

5) MAIL a thank-you letter to a hero of yours. Don't ask for anything; just thank them. Be specific in your gratitude.

6) TYPE OUT a rave review. Imagine you are a reporter *discovering* your art. What do you appreciate about it? What makes it unique? Where can you find it?

SUPER CHALLENGE

Do improv, a storytelling show, or five minutes of open mic stand-up.

(Write about your experience.)

DETAIL CHALLENGE

Draw something you noticed today that you think no one else noticed.

Why do you remember it?

TAKE A NUMBER

Have you ever taken a number at a deli counter? Time slows down. Waiting is slow. Expectation is slow. Feeling as if you have to be vigilant in order not to miss your "rightful" turn is tiring.

Waiting for your big break can feel like this. And God forbid someone with a later number than yours gets help. Then there's hell to pay!

But the artistic life is not orderly and it's not fair. You don't get what you "deserve" just because you have been waiting the longest. To best deal with this terrible reality, I suggest this: Make your own egg salad. While you wait for your number to be called, keep being creative. Look around the market. Find ways to make the thing you are waiting for. It might not be as good to start, but it will get better.

What egg salad—er, I mean . . . project can you self-produce?

THE NO-GUILT DROPKICK

Toss this book across the room. Kick it up your staircase. Or . . . just put it down.
Sometimes in the creative process we need to step back. Give yourself a break.
Let the little angels and gremlins inside you duke it out on their own.

Try one of these instead:

- ☐ Coffee
- ☐ Cat cuddling
- ☐ Candle making
- ☐ Dressing up
- ☐ Dressing down
- ☐ Naked needlepoint
- ☐ Beard maintenance
- ☐ Laser tag
- ☐ Photo organizing
- ☐ Homemade pickling
- ☐ Weeding
- ☐ Shoe repair
- ☐ Elegant lounging
- ☐ Toe massage

SUPER CHALLENGE

Invite the critics.

Invite the press.

Put your work out there and invite eyeballs to see it.

DOUBLE SUPER CHALLENGE

Don't worry about what the critics or the press have to say.

You might think, *Well, then what is the point of inviting them in the first place?*

Here's the point: When you invite people to observe what you do, you signal to yourself that you value what you do. Your work improves in this environment.

It also acknowledges the fact that there will never be an "end time" when everything is perfect and ready to be seen.

Everything we create is an expression of where we are at *this* moment. We are evolving and learning all the time.

How was this experience for you?

#10
YOU DON'T HAVE TO CALL YOURSELF AN ARTIST

Just keep putting your work out there.
I promise other people will start saying it for you.

You don't have to call yourself an artist. You are one.

The process of living in that understanding, however, is ongoing.

Why?

Because of value and judgment. We place a certain value on art. We base that value on numerous things: money, awards, notoriety, and so on. We judge what kind of artist we are almost from the beginning. We feel the need to label what we are, what our art is, but the goal is to allow the value of what we do to stem from our purity of heart, our dedication, and our joy of creation.

When we place the value of our art in the honesty of our efforts and our kindness, the art can breathe. When we place the value of our art in the quality of our collaboration with others, the art is lifted. Investing in this positivity is vital.

Why?

Because the bottom line is this: *There is a lot to create.* There is a lot to draw and write and design and produce. We need to get out of our own way! When we nurture the positive aspects of our work, we create more. When we nurture the positive aspects of our collaborations, we extend our network.

Worry less about the labels you have and more about doing the best work that you can in *this moment*. Funnel your intensity *not* into the harshness of your own self-judgment but into the flurry of creativity.

Make things. Put them out there. Say yes. Try. Enjoy. Listen. Learn.

Do the work. Let the label follow.

Do the work and discover what it is that you need to express.

FRAUD PAGE

As we continue to create, one fear that emerges is that of being exposed as a fraud.

This fear has its roots in attachment. Somewhere along the line, we started to see ourselves as "experts." Far from endowing us with a sense of freedom, this attachment can bog us down in inaction. To battle this fear, begin by discovering your attachments, and *let them go*.

USE THIS MANTRA AS YOU BREATHE

"I let go. I surrender. I release."

LABELS

Do you like to label yourself? "I don't do social media," "I'm not the producer type," and so on?

Labels can make us feel more in control and help us prioritize. *But* they can also lock us in. What are some of your oldest labels? Are they still valid?

I'll start, you finish . . .

"Wanderer, there is no path, the path is made by walking."

−ANTONIO MACHADO

TAKE TWO DEEP BREATHS PER DOT

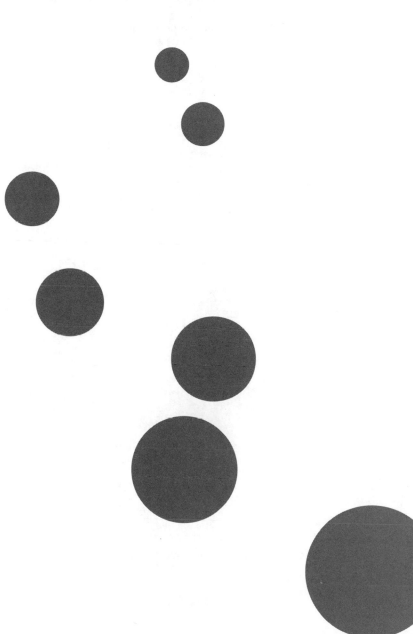

SHED IT!

Getting rid of extraneous stuff will help you focus as a person and as an artist.

Go through your home. Get rid of what you don't need or don't like.

☐ Kitchen ☐ Bedroom ☐ Living Room ☐ Bathroom ☐ Bonus Room ☐ Garage

Draw or describe a dream "creative space."

BONUS

What is the weirdest thing you found in your search?

GOALS

Write out some goals.

What are your fears about them?

What do you hope to feel when you achieve them?

Rip out this page, fold it, and seal it. Revisit it after one year.

GOALS

Draw lucky talismans on the back of your goals page.

Here's a game.

NOBODY ACTUALLY SAID THAT

Sometimes we play back bad comments or criticism in our minds that we *imagine* other people are saying about us. What are some negative things you think about yourself that *nobody* actually said?

(Sometimes we are our own worst enemy.)

Feel free to draw smiley faces *all over* this page
and cover up the negative comments.

TASKS: PICK A FEW

1) GUERRILLA ART

Make a small piece of art. Hide it where a stranger will find it.

2) RECIPE

Feed people well. Treat people well. They will be your film crew, your first patrons, your merchandise table volunteers. Artists are actually in the "people business." All of us. Work out a new, super-yummy recipe to share.

3) Rx

Take a vacation from your problems.

(See the movie *What About Bob?*)

4) RECIPE 2.0

Find the *good* pizza place near your work space. Many a project was built on the back of bread and cheese.

5) BABY PAGE

Write or draw that first moment of inspiration. Describe what it felt like to see the magic *before* you knew some of the things you know now.

6) THE PARTY

Who do you want at your after party? AFTER you've won the big award, who would it be incredible to see come celebrate you?

Check a box for every positive action you take with your art.

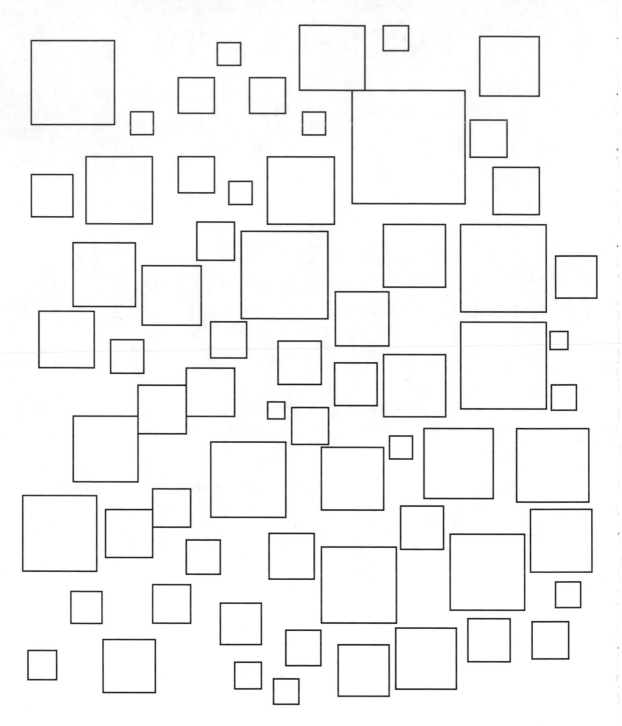

When all the boxes are checked, sign here: _____

#11
NOT-SO-SECRET
BONUS TRACK

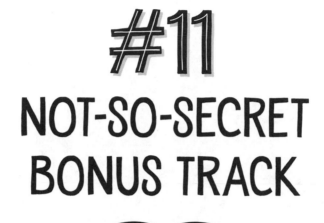

We choose to create it. We choose to give it importance.

Things are beautiful
because we make
a sacred space for them.

We create the art.

We create the space.

SAPPY LOVE LETTER

If your ART were a person, what love letter would you write to it?

WHO ARE YOU INVESTING IN?

The people you spend the most time with are the people you are developing artistic ties with.

Invest in the people whose art you *like*.

As I was finishing up writing this book, I came across an old note I had written to myself back in 2013. I had forgotten all about it.

Apparently the seeds for what would be written today had been germinating then.

It reads as follows (please excuse my sloppy handwriting and terrible grammar):

My birthday gift to myself. Completely change the way I look at mistakes. They are beautiful. They are gems! They are to be cherished! My whole life is different now. Love flaws. Celebrate them. Never feel the need to hide them. Don't overshare. Overshare is the same as hiding. But to really love your flaws. Flaws in general. This is the change. We desire perfection. We desire to become an IMAGE of something that we see in our mind's eye. This desire is strong. We compare where we are, who we are currently with this image. Constantly. The differences are our flaws. The best improv is ALL about celebrating flaws. Jumping on mistakes. Celebrating them. Convoy [an improv team at Upright Citizens Brigade] does this. All great improv teams do this. If you love mistakes . . . (BECAUSE) you love mistakes. You love to look at them. To analyze them. Growth is easy. Growth is fun. Growth is fast. Growth is a party. Love life. Happy Birthday Year.

So . . . a couple of thoughts. Apparently I was planning on celebrating my birthday for a whole year. Also, it reminds me of the need to "feed the well." We are affected by all our past thoughts, even if we don't consciously remember them. So let's be aware of what we are feeding ourselves. And write! Write things down. If we can at least start with something positive in writing, then perhaps over time our verbal self-talk will get better as well.

My birthday gift to myself:

Completely change the way I look at mistakes.

They are Beautiful. They are GEMS! They ARE to be
CHERISHED!

blue gems → 💎 My whole life is different now. 4/17/2013

Love Flaws. Celebrate them.

Never feel the need to hide them.

Don't Over share. Over share is the same as hiding.

But to really love your flaws. Flaws in general
this is the change.

WE desire Perfection. we desire to become an IMAGE of
something that we see in our minds eye. This desire is strong.
We compare where we are, who we are currently with this image.
Constantly. The differences are our flaws.
THE Best improv is ALL about celebrating Flaws. Jumping on mistakes. celebratg
them. Convoy does this. All great improv teams do this.

If you love mistakes ... (BECAUSE) you love mistakes. You Love
to look at them. To analyze them. Growth is easy. Growth is fun.
Growth is fact. Growth is a party. ✷PARTY✷

Love Life.
HAPPY BIRTHday YEAR.

"If you hear a voice within you say, 'You cannot paint,' then by all means paint, and that voice will be silenced."

–Vincent Van Gogh

HAVE YOU LOST PERSPECTIVE?

HATE EVERYTHING YOU HAVE EVER DONE?

TAKE A BREAK.

PLEASE.

BEFORE YOU RIP UP THE PAGES.

BEFORE COMMAND+A+DELETE.

IF YOU MUST DESTROY SOMETHING,
TEAR UP THIS CORNER.

FEEL BETTER?

NO?

WELL . . . IT IS ONLY A TINY
CORNER OF A PAGE.
SEE HOW YOU FEEL
TOMORROW.

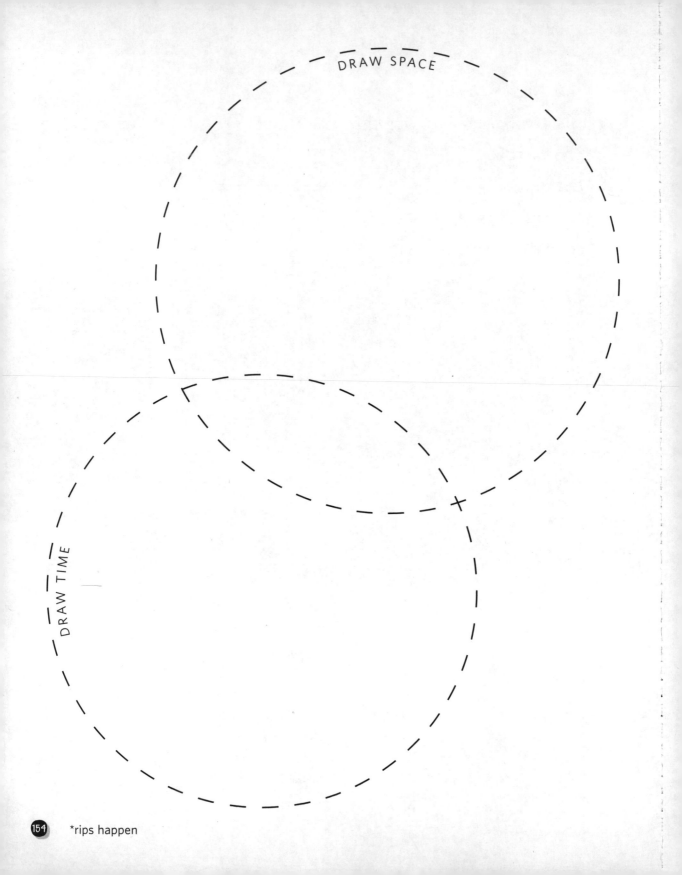

DRAW SPACE

DRAW TIME

*rips happen

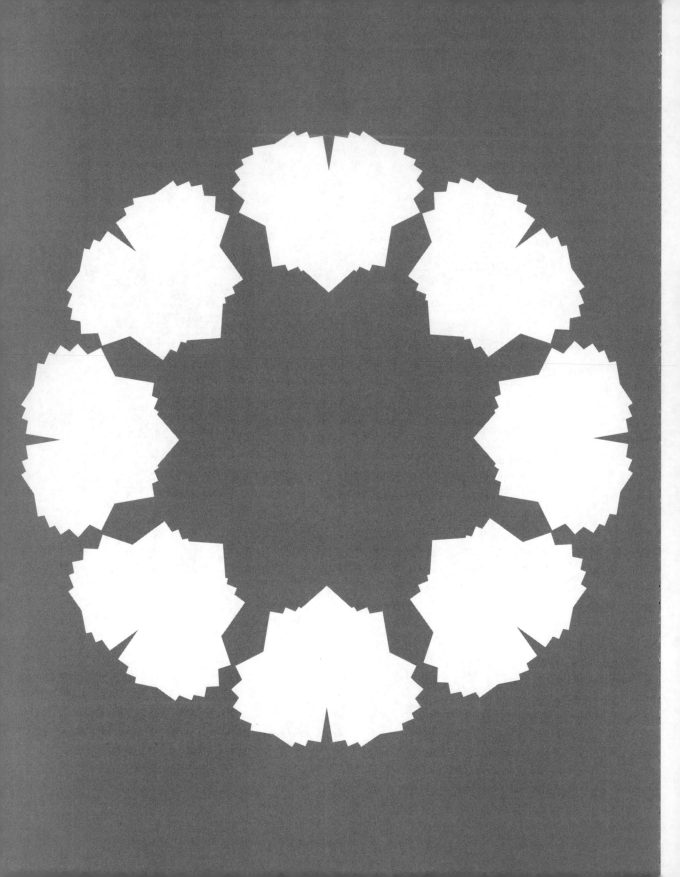

PERFECTION CHECK-IN

Pick *one* thing in your life that you have to be perfect about (children, baking, work, etc.).

Now imagine that you let *everything* else in your life go. You don't have to be perfect at *anything* else.

Meditate on this.

Enjoy a sense of relief. Find the strength in allowing more possibilities, more freedom in your expression!

OK, great. Now: Did you actually pick something, and did you actually meditate, or did you just skim down to this part? That's OK. I'm just checking. OK, cool.

Now go back to that first thing. Surrender the desire to be perfect at *that* too.

Perhaps you knew that I was going to say that. Because you are smart and because you read the title of this book.

SECRET: I have found that the smarter a person is, the harder it is (sometimes) to get lost in the moment. Just because you *can* see three steps ahead doesn't mean you have to. Enjoy the process. Dig in! Invest! Be in the moment. Surprise yourself.

ACKNOWLEDGMENTS

First, thank you to Kevin Porter and Demi Adejuyigbe for having me on the *Gilmore Guys* podcast and getting me in touch with the fabulous Amanda Shih (my first editor) and the incredible Monica Odom (my agent). This book would never have existed without you four.

My Agena and Tokuda family. You are my rock. What does Shin say when he's rolling the dice at craps? I think it's "For the fam, bam!" Of course, this includes the Kawasaki household. Our little family of two.

My improv family. Ham Radio, RJP and Dave, Totally Heather, and Kilowatt. All the teachers at iO, Groundlings, and UCB. My favorite improv team, the Smokes. Special shout-out to Will S. Choi, my writing partner, producer of Asian AF, and co-host of the *Drunk Monk* podcast.

My L.A. friends. Everyone I've ever met through Tuesday Night Projects or in the Okamotos' living room or who's sat on my couch for Groundhog Day. Special shout-out to Grace, Elissa, Traci, all the Jennys, and the Ferrabees.

Much appreciation to all the folks in Shamers, especially Sarah Kuhn.

My acting teachers Linda Johnson, Laura Henry, Brian Clark, and Lesly.

Erik Kritzer, Blake Bandy, and Joseph Le for always keeping me on track and watching out for me.

Amy, Dan, Helen, and all the incredible cast and crew of *Gilmore Girls*.

Kathy and Nekole for being there for me when I really needed it and being so selfless and so giving.

And Reef!

For your smile.

Every day is better because of it.

AUTHOR PHOTOGRAPH: MARK UEHLEIN

Keiko Agena is best known for the TV show *Gilmore Girls*, in which she played Lane Kim for eight seasons. She has also been a series regular on *The First* and has appeared as a guest star on shows such as *NCIS: Los Angeles*, *13 Reasons Why*, *Shameless*, *Scandal*, and *Bajillion Dollar Propertie$*.

She's a cohost of the popular UCB show Asian AF, which has a monthly spot at the UCB Sunset. The success of the show has even spread to the East Coast! There is now an Asian AF in New York. Agena is a graduate of the UCB and iO West improv programs and is a member of the UCB Academy.

As a visual artist, Agena continues to explore and grow. Her passion for art reemerged in 2015 as a gift of time and a Micron 0.20mm pen opened up a new world to be obsessed with. At the moment of writing this bio, Agena is *most* excited to start a new art series based on a relistening of Leonard Cohen's last album, *You Want It Darker*.